THEN & NOW

STAFFORD COUNTY

THEN & NOW

STAFFORD COUNTY

Anita L. Dodd and M. Amanda Lee

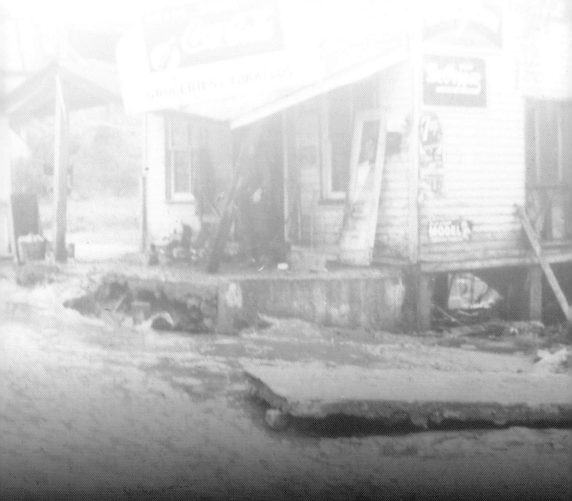

For my grandchildren, Keith, Kyle, Kurtis, Alec, and Ethan, who are the wind beneath my wings.—ALD

For my Stafford friends and family who have and continue to share their love and knowledge of place and time.—MAL

Library of Congress control number: 2006937138

Published by Arcadia Publishing
Charleston SC, Chicago IL, Portsmouth NH, San Francisco CA

Printed in the United States of America

For all general information contact Arcadia Publishing at:
Telephone 843-853-2070
Fax 843-853-0044
E-mail sales@arcadiapublishing.com
For customer service and orders:
Toll-Free 1-888-313-2665

Visit us on the Internet at www.arcadiapublishing.com

ON THE FRONT COVER: Virginia's Underwood Constitution of 1869 established state control of public education and provided the general assembly the power to pass attendance laws. The *c.* 1925 Falmouth High School, located off Melcher's Drive in Falmouth, has served as the T. Benton Gayle Middle School and currently functions as the Gari Melcher's Complex and houses Stafford's Head Start program. (SH.)

ON THE BACK COVER: Francis Benjamin Johnston, a Washington, D.C., photographer, was commissioned by Mrs. Daniel B. Devore of Chatham to document structures in the Falmouth and Fredericksburg area "as a historical record and to preserve something of the atmosphere of an old Virginia town." The 1927 photograph depicts a small clapboard house located along King Street in Falmouth with the Cambridge Inn in the background. The house was demolished in 1928. (LOC, FBJ.)

CONTENTS

ACKNOWLEDGMENTS

An undertaking such as trying to illustrate the history of place, both its past and present, would not have been possible without the generous help of friends, family, and those Stafford residents who have taken the time to collect and save images and who continually amaze us with their willingness to share not only their photographs but their knowledge and time.

A heartfelt thank you is extended to Barbara Flack (BF), Shirley Heim (SH), Ted and Anne Jones (T&AJ), H. Stewart Jones (HSJ), Barbara Kirby (BK), and Mary Cary Kendall (MCK) who shared historic photographs from their personal collections. The authors appreciate the assistance of Kathy Massie from Stafford Head Start, who made the Now cover image a reality. We also acknowledge the helpful and professional staff of the Library of Congress's Prints and Photographs Division (LOC) who aided us in locating images from their general collection, the Historic American Buildings Survey, and the Frances Benjamin Johnston (FBJ) Special Collection. The authors acknowledge the use of both photographic and research materials in the Library of Virginia's (LVA) and Virginia Department of Historic Resources' (VDHR) collections. All other images are from the collection of Anita L. Dodd.

We would especially like to thank Barbara Flack, H. Stewart Jones, Mary Cary Kendall, Barbara Kirby, Eric Mink, Norman Schools, and Wendy Wheatcraft for sharing their research files and for taking the time to review portions of the text. Your encouragement and enthusiasm sustained us throughout the course of the project.

To Robin Hughart, we are indebted for her patience and good humor as she aided us with our initial attempts at scanning. A grateful thank you is extended to Rodney Miller, who was instrumental in providing technical support and help in scanning oversized images, and DLR Contracting, Inc., for the use of their large flatbed scanner.

M. Amanda Lee would like to thank her parents, Richard and Martha Lee, for instilling in her a love of place and family and for setting her on the path to a career in public history and historic preservation. Amanda would also like to thank her coauthor, Anita L. Dodd, for willingly tackling this project and Robert Dodd for allowing the authors to interrupt his weekends as they took over the house with their ever-growing research files.

Anita Dodd would like to thank her coauthor for her friendship, which led to this project, a true labor of love for both of them. Anita would also like to thank her children, Robin and Rob, and especially her husband, Robert, for their continuing support and encouragement throughout this project and in everything that she has set out to achieve.

INTRODUCTION

Then and Now: *Stafford County* is designed to portray, pictorially, the history of Stafford County from exploration and settlement in the 1600s to the present day. The thematic focus of the book is the settlement patterns and evolution of the built environment of the county in general and more specifically the present-day election districts, including George Washington, Falmouth, Hartwood, Rock Hill, Aquia, Garrisonville, and Griffis-Widewater. In general, the book is organized according to the *c.* 2005 election districts in order to facilitate the location of architectural resources and associated sites. Then and Now: *Stafford County* is not intended to be an all-inclusive pictorial history, but one that provides both established and new residents a glimpse at the ever-changing and evolving landscape. It is hoped that this volume will open the doors to positive discussions regarding the preservation of the county's cultural resources and additional photographic documentation of the area.

Stafford County is located midway between the metropolitan areas of Washington, D. C., and Richmond, the capital of Virginia. Founded in 1664, Stafford has strong connections to events that shaped our nation's history. The county's prosperous colonial iron industry attracted Augustine Washington, with the rest of his family—including a six-year-old son named George—to what is now called Ferry Farm. The future first president spent his formative years there until he reached young adulthood. In 1727, Falmouth was incorporated and served as a transshipment center for tobacco, grain, and cotton. Mining and quarrying were important early industries in the county. James Hunter's iron works, also known as Rappahannock Forge, furnished arms for the American Revolution. Aquia sandstone, quarried in abundance on Government Island in northern Stafford, provided stone for the White House, the U.S. Capitol, and trim for churches and private homes.

Due to Stafford's location midway between Washington, D.C., and Richmond, Virginia, and proximity to the Richmond, Fredericksburg, and Potomac Railroad and its terminus at Aquia Landing, both Confederate and Union forces occupied the county. While Stafford was not the location of any major Civil War battles, it most certainly felt the effects of the war as more than 100,000 Federal troops occupied Stafford for most of the war years, particularly the winter of 1862–1863.

After the Civil War, Stafford County was an agricultural community that sought to rebuild itself through the fishing, timber, and dairy industries. Historically, Stafford County can best be described as a collection of small farming communities that were isolated from one another and widespread throughout the countryside. These small communities tended to be centered around a country store or milling complex at a crossroads. With the development of the automobile and its associated infrastructure, Stafford slowly began its transformation into a bedroom community of Washington, D.C., a transformation which has accelerated since the 1970s.

GEORGE WASHINGTON DISTRICT

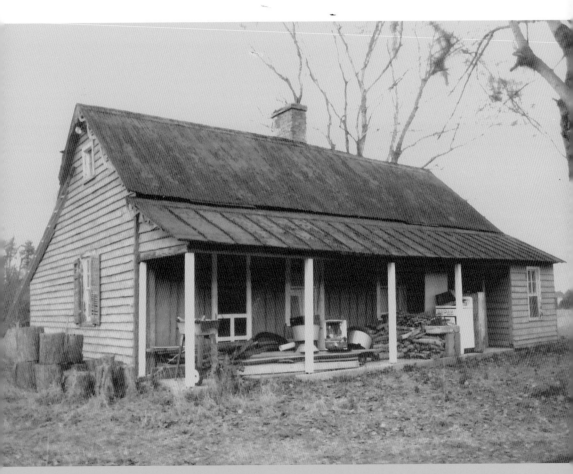

The mid-19th-century Mix family log home is indicative of a type of single-family, vernacular dwelling that was once common in rural Stafford County. As a family's fortune and tastes changed, early log homes often were covered in clapboard siding and additions were appended to the original structure. Porches provided both shade and additional work and storage space.

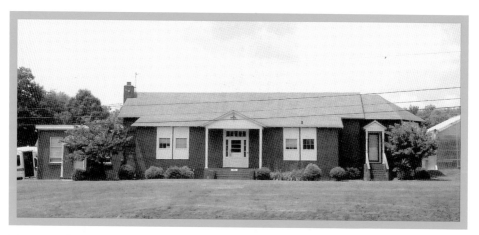

This 1935 photograph shows the *c.* 1912 Little Falls School located on Route 3 East. Little Falls School served first- through sixth-grade students from southeastern Stafford. The building was originally covered in clapboard siding but was later improved with a brick veneer. Today it is used by the Rappahannock Area Community Services Board as an adult center. (SH.)

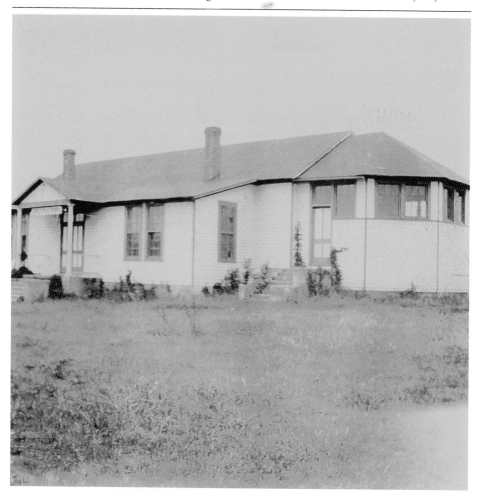

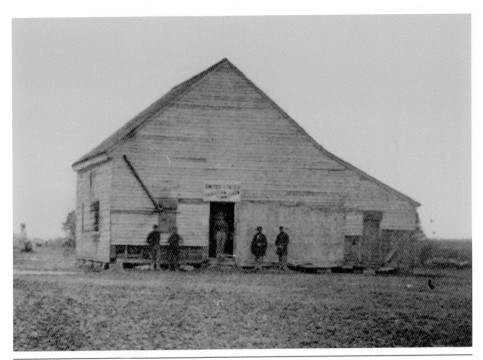

The White Oak Primitive Baptist Church was established in October 1789 and began meeting at its current location on the south side of the intersection of White Oak and Caisson Roads in 1835. Between 1862 and 1865, the Union army commandeered the building. It served many functions, including a headquarters for the United States Christian Commission, during the Civil War. The earliest known burial is *c.* 1897. The building and graveyard continue to be used by the congregation. (LOC.)

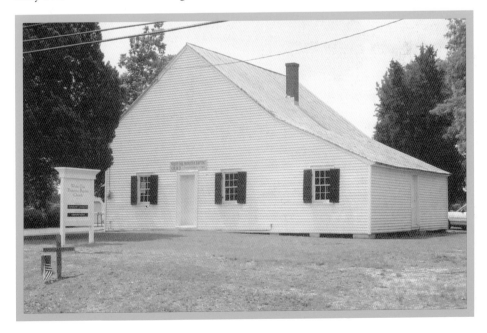

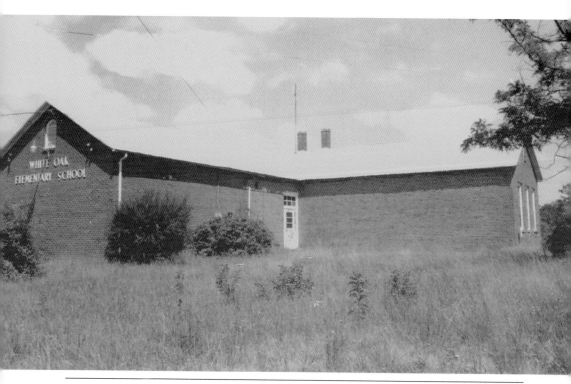

The early-20th-century White Oak Elementary School is located on the northwest corner of the intersection of White Oak and Caisson Roads. Originally a one-room clapboard building, the school evolved through the addition of wings to accommodate the expanding population of first- through fifth-grade students as well as a brick veneer. By the time of the *c.* 1980 photograph, the building no longer functioned as a school. Today it serves as the White Oak Civil War Museum.

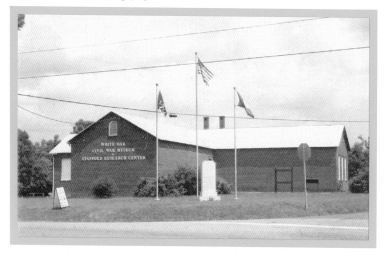

The *c.* 1925 New Hope Elementary School is located on the south side of White Oak Road. The one-story building has a five-bay central projecting pavilion on the north elevation, which originally had a front-gabled projecting porch. Front-gabled wings are located to the east and west. The school closed its doors around 1970 when students began attending other area schools. (SH.)

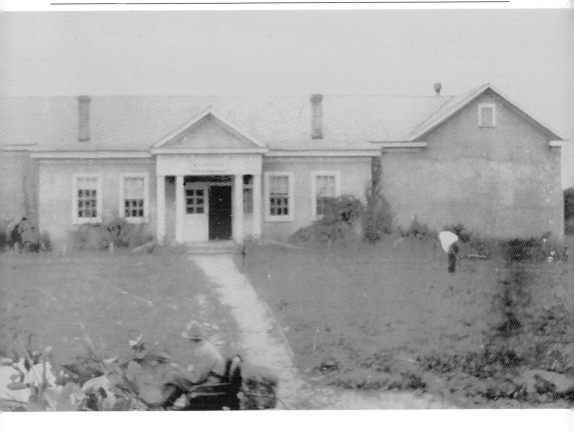

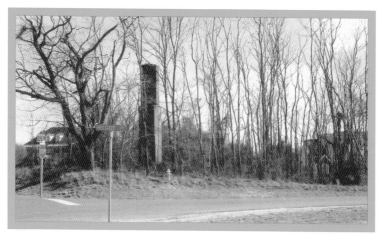

William H. Fitzhugh built New Boscobel around 1820 for his daughter. Sometime before the Civil War, the dwelling came into the possession of the Edwards family, who enlarged the house. The 1897 photograph shows the Edwards family and kitchen dependency, which was attached by a hyphen in 1890. The house burned around 1985. The chimneys are all that remain of New Boscobel and are preserved at the corner of Holgate and Ivy Creek Lanes in the Fitzhugh subdivision.

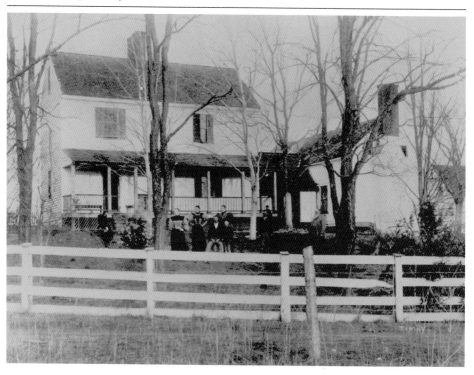

Owned and operated as a farm by the Strother, Washington, Mercer, Bray, Carson, and Colbert families, Ferry Farm is best known as the boyhood home of George Washington. Pictured is what has been called the "surveyor's office." The building was constructed in the 1870s as a dwelling for a farm hand. The *c.* 1914 photograph illustrates the relocation and attachment of the Carson house to the structure. Today the building is part of the George Washington's Fredericksburg Foundation's Ferry Farm on Route 3. (LOC.)

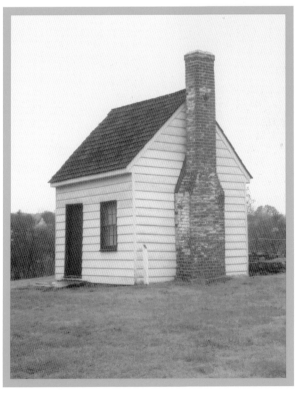

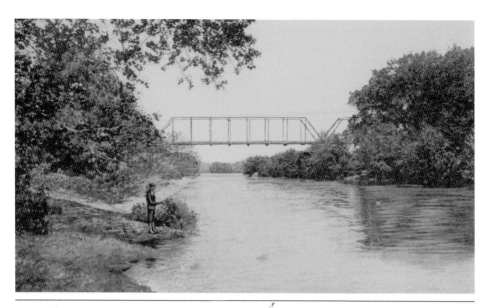

The "Free Bridge," as it was known in the late 1920s, was erected after the Civil War and crossed the Rappahannock River where Route 3 and River Road now intersect, connecting Stafford County to the city of Fredericksburg. This site was the location of at least two previous spans, including Scott's Bridge and Coulter's Bridge. The steel bridge was destroyed by the 1937 flood and was replaced by the current bridge, which is known as the Chatham Bridge.

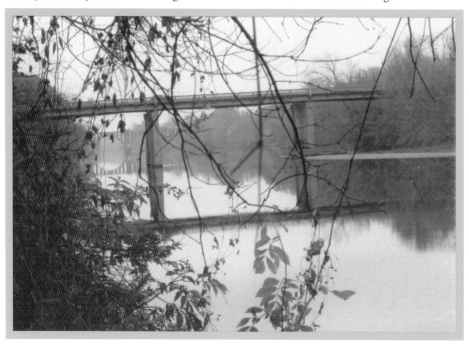

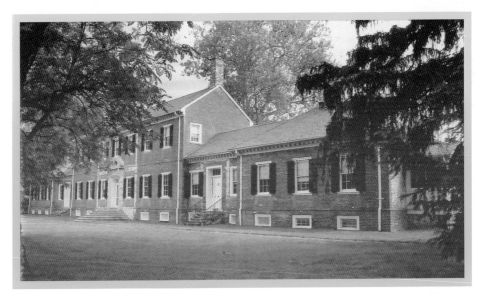

Constructed between 1768 and 1771, Chatham was the home and plantation of a number of families, including the Fitzhughs and Lacys. With its location along the Rappahannock River and view overlooking the city of Fredericksburg, the house and grounds functioned as a Union headquarters and field hospital during the Civil War. The estate was restored in the early 20th century and willed to the National Park Service in 1975. It is now open to the public and serves as the park headquarters.

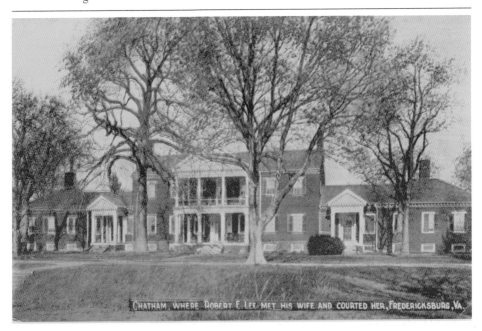

CHATHAM WHERE ROBERT E. LEE MET HIS WIFE AND COURTED HER, FREDERICKSBURG, VA.

Pictured is Steward Cox standing on the foundations of the Counting House amid the debris from the 1942 flooding of the Rappahannock River in Falmouth. In the background, from left to right are the Moncure Conway, Basil Gordon, and Ernestine Payne houses. While the Ernestine Payne house was demolished around 1972, the Basil Gordon and Moncure Conway houses still stand near the intersection of Gordon Street and King Street. (T&AJ.)

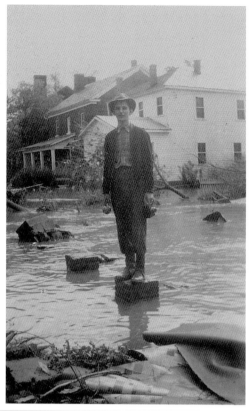

This view of Gordon Street looking south toward the Rappahannock River was taken shortly after the flood of 1942. Note the dirt street and the white frame house at the end of the road. The white frame dwelling belonged to Ernistine Payne and sat next to the Basil Gordon house. The Payne house was destroyed in the 1972 flood, leaving an empty lot where it once stood. (T&AJ.)

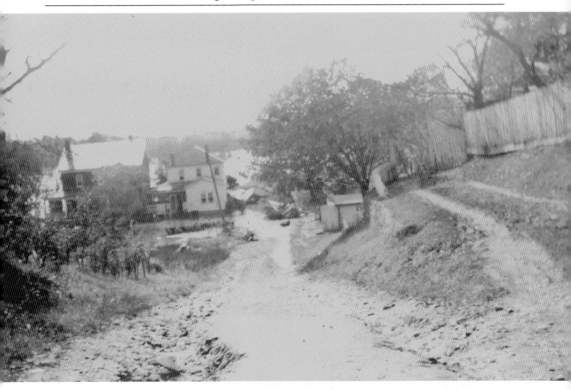

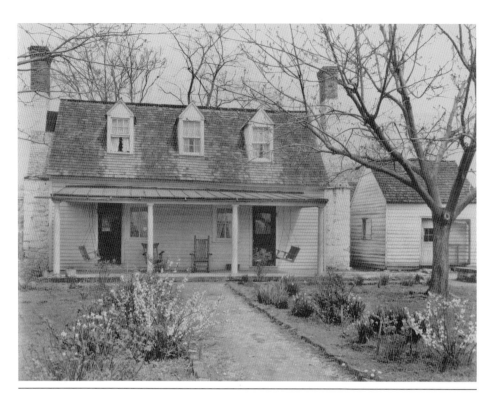

Once an early 19th-century kitchen, Dunbar's Kitchen was converted into a dwelling. The appearance of the house, which is located at the intersection of Carter and Gordon Streets, has changed little since the 1930s; however, 20th-century growth now surrounds the building. Its current owners are restoring the house. (LOC, FBJ.)

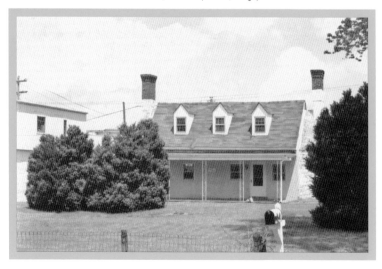

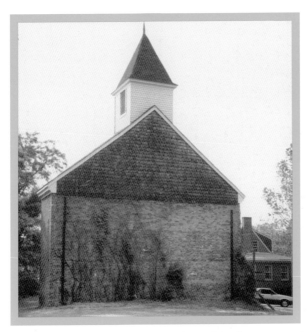

The narthex is all that remains of the Union Church, located at the elbow of Carter Street. The first church was a wooden structure built around 1750, which burned in 1818. The second church was constructed of brick around 1820. This church was dismantled, except for the narthex, after a hurricane in the 1950s damaged the building. The church is called Union Church because four denominations—Episcopal, Baptist, Methodist, and Presbyterian—used it on alternate Sundays. (LOC, FBJ.)

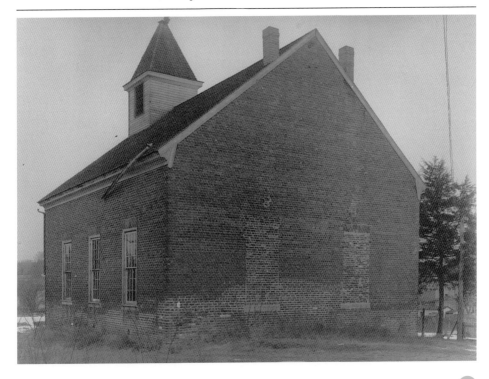

"Joe" Jett Armstrong, with his cow, stands at what is now the crossroads of Butler Road and Carter Street in Falmouth. Probably taken sometime in the 1920s or 1930s, this photograph illustrates the road conditions at that time in Falmouth.

The line of farm buildings in the background are associated with the Jett family farm. The middle structure in this group of farm buildings is a corn crib.

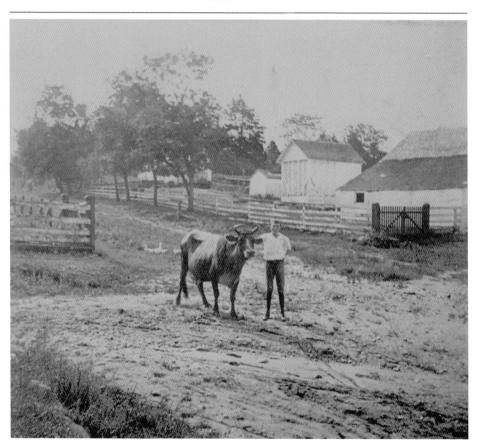

FALMOUTH DISTRICT

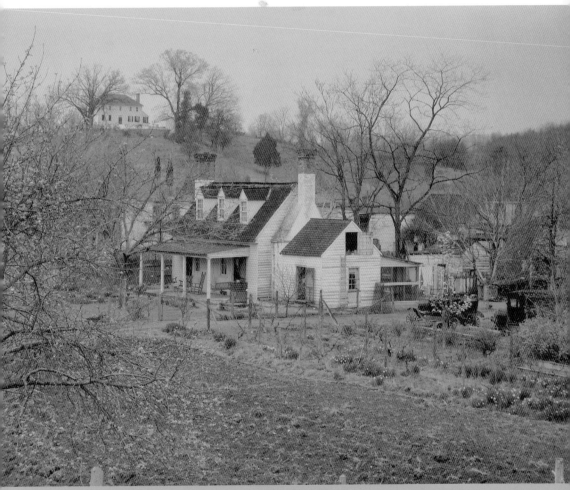

In the 1930s, a tranquil, bucolic setting is portrayed with Carleton in the background on the hill. Today U.S. Route 17 passes to the left of Carleton as it makes its way to meet the future U.S. Route 1 at the bottom of the hill. (LOC, FBJ.)

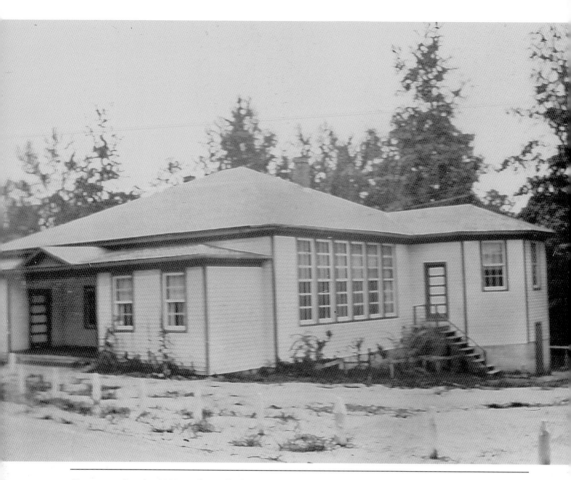

Constructed in the 1930s, Falmouth Elementary, located along Butler Road, served the first through the fourth grades. The distinctive polygonal apse housed a stage area for school productions. Although the apse is no longer visible due to subsequent additions, the adjacent wall that contained the large window grouping is still visible. In the 1970s, the building became the offices of the Fredericksburg Stafford Park Authority, known as the C. Ray Grizzle Activity Center. (SH.)

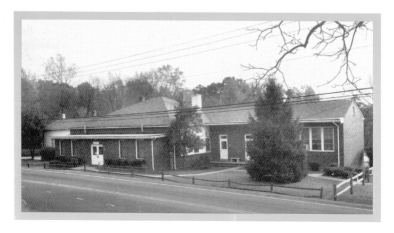

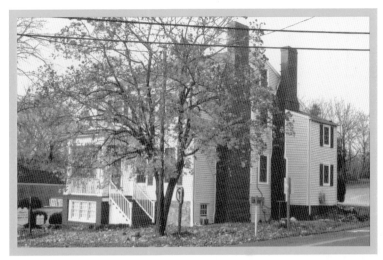

The manor located at the corner of Carter Street and Butler Road was constructed around 1790 by the McNeal family. It was later purchased by Col. Thomas Waller, whose family used it as a summer retreat from Clifton, their Widewater home. In 1880, E. B. Jett purchased the property. Five generations of his family have resided there. During the Civil War, the house was used as a headquarters and hospital for the Union army. The building now houses the law offices of Gordon Gay. (LOC.)

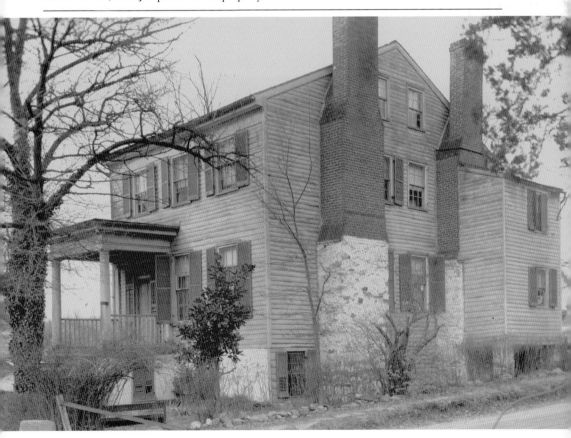

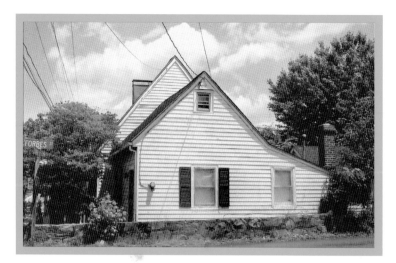

Located at the intersection of Forbes and Cambridge Streets, this dwelling was once the home of Austin Boutchyard. This small house has been adorned with a Greek Revival portico with square columns and heavy dentils. The steeply pitched roof of the original center portion of this early-19th-century house is one of three found in Falmouth. Additions made to the dwelling have enlarged it to its 20th-century configuration. Other changes include parging the brick chimney, vinyl siding, window upgrades, and screening the front porch. (LOC, FBJ.)

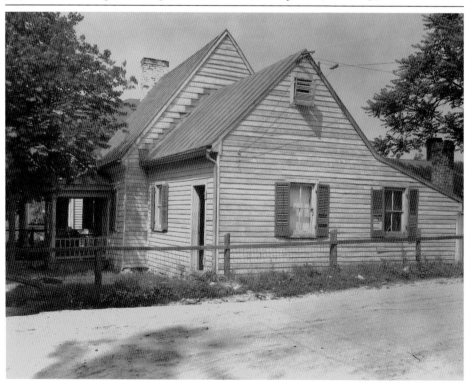

A Falmouth slaughterhouse complex was located about one quarter-mile north of the intersection of U.S. Routes 1 and 17 on the Austin Boutchyard property. This operation was used by the local community some time in the first half of the 20th century. The complex included two rows of pens used to house the animals awaiting processing and the slaughterhouse itself. The buildings were demolished in the 1970s. The open field is all that attests to their presence. (T&AJ.)

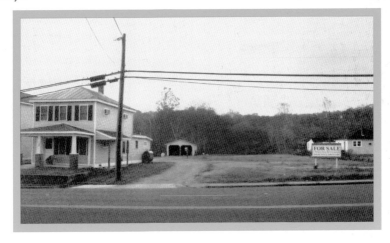

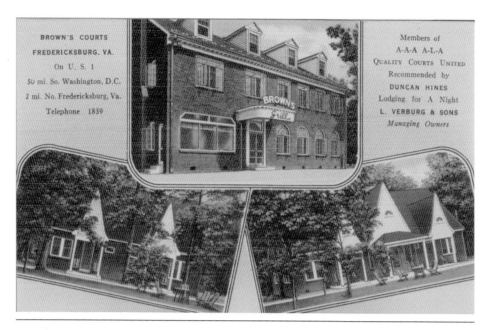

Brown's Motor Court, also known as the Brown's Cottages and the Brown's Auto Court, is located two miles north of Fredericksburg along U.S. Route 1. Built sometime in the 1930s, it advertised having an automatic hot-water heating system, Beautyrest mattresses, Ace coil springs, private baths, 20 locked and heated garages, and hot and cold water. Because of the improved roads of the 1930s, automobile travel became more attractive, and accommodations such as this dotted the landscape of major highways.

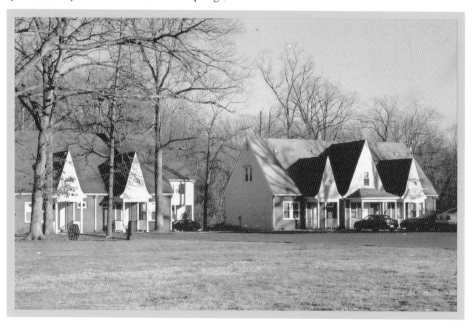

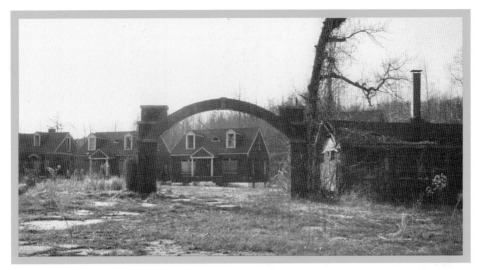

Victor's Hollywood Auto Court was one of many motels that lined U.S. Route 1 when it was the main thoroughfare from Maine to Florida. The auto court was located near the Mountain View Road–I-95 interchange. Victor Menache managed the 15-acre complex, which included a restaurant, cabins, and a Greyhound bus rest stop. The auto court advertised steam heat, soundproof brick cottages, private baths in every room, Beautyrest mattresses, and peasant-type Swiss furniture. A large dining room served Southern fried chicken and Virginia ham.

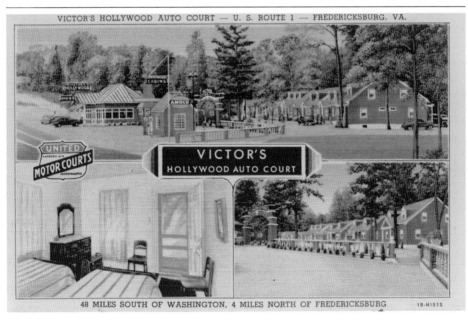

VICTOR'S HOLLYWOOD AUTO COURT — U. S. ROUTE 1 — FREDERICKSBURG, VA.

VICTOR'S
HOLLYWOOD AUTO COURT

48 MILES SOUTH OF WASHINGTON, 4 MILES NORTH OF FREDERICKSBURG

Gordon Green Terrace is named for two of its previous owners, Samuel Gordon and the Green family. Constructed by Gordon, the original, late-18th-century portion of the house is the one-and-a-half-story brick section on the left. Both Samuel and his brother, Basil, were engaged in the cotton and grain exchange in Falmouth. The terraces at the front of the dwelling were compromised in the early 1940s with the construction of U.S. Route 1 and the realignment of the Falmouth Bridge. (LOC, FBJ.)

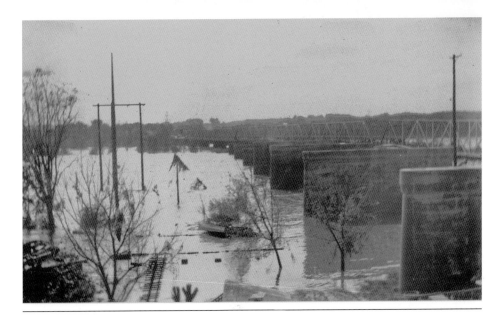

The first Falmouth Bridge, located at the south end of West Cambridge Street, was washed away in the 1937 flood. A foot bridge was constructed across the Rappahannock River while waiting for the replacement bridge to be constructed. In 1942, construction of a new Falmouth Bridge had begun when another flood breached the newly constructed piers for this bridge. At this time another foot of concrete was added to the piers, with the hopes of avoiding future flood problems. (T&AJ.)

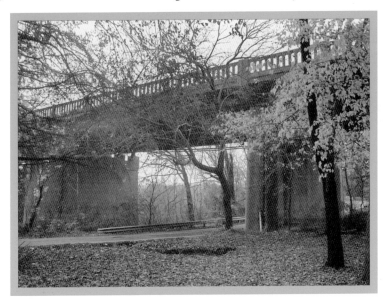

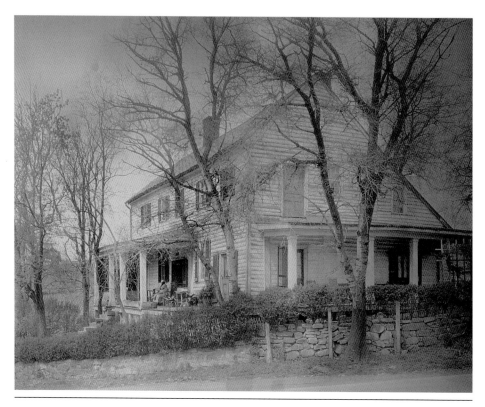

At the north end of West Cambridge Street, the Cotton Warehouse now houses Simpson's Reality. This structure was originally constructed in the late 18th or early 19th century as a dwelling. Later in the 19th century, it was used as a cotton warehouse when Falmouth was a thriving port town. Sometime in the first half of the 20th century, the Brooks family converted the structure back into a dwelling and added porches. Helen Turner, a local midwife, sits on the porch. (LOC, FBJ.)

Alterations and wings to the north and west elevations of the house at 125 West Cambridge Street have been added since the 1930s photograph was taken. However, the original footprint of the dwelling remains. The sign on the magistrate's office, to the left of the dwelling, reads "Falmouth Health Center Open Every Third Friday." Note the dirt road and lack of sidewalks in Falmouth. (LOC, FBJ.)

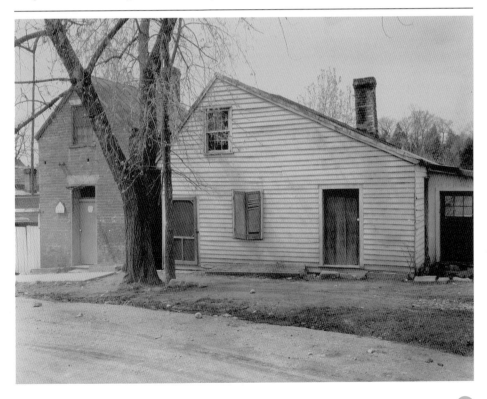

Mr. Lightner stands in front of this late Federal-style building. Built *c.* 1830, the first mention of the building is an 1885 Sandborn map identifying it as a courthouse. In the 19th and early 20th centuries, magistrates traveled throughout the county holding court in each small community. In Falmouth, this building was used for that purpose. From the early 20th century to the 1950s, it was the voting place for the Falmouth District. (LOC, FBJ.)

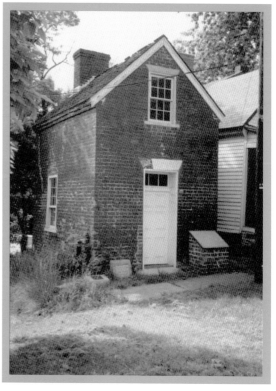

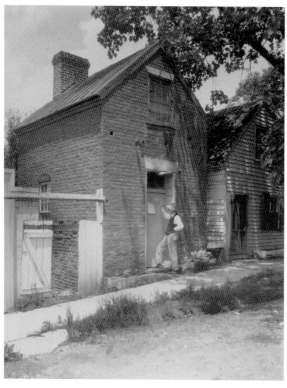

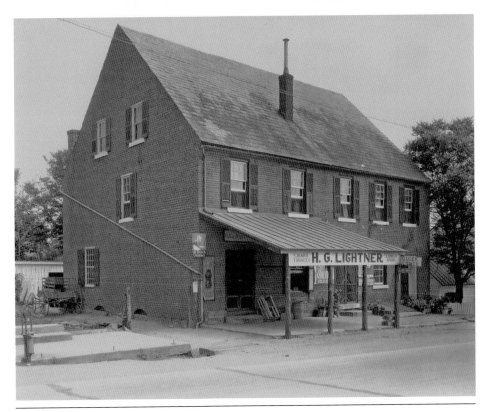

The Lightner Store, located at the north end of West Cambridge Street, was constructed in the 1830s by Basil Gordon as a warehouse, one of many warehouses that lined West Cambridge Street. The structure was purchased by the Lightner family sometime in the 1930s and converted to a residence above with a store and lunch room below. The removal of the front porch brought the front elevation back to its original configuration. (LOC, FBJ.)

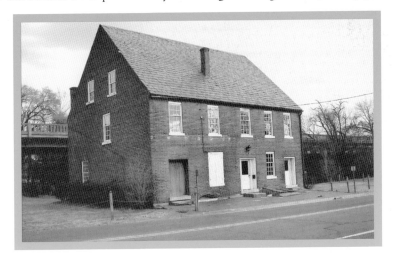

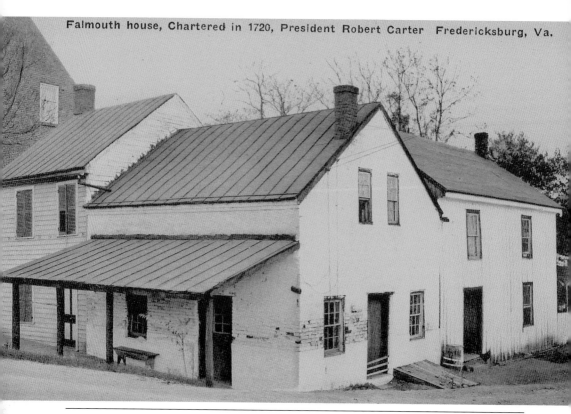
Falmouth house, Chartered in 1720, President Robert Carter Fredericksburg, Va.

This 1930s postcard illustrates a group of structures that once occupied the corner of West Cambridge and King Streets. The largest structure, known as the Falmouth House, was a saloon. This complex of buildings was demolished sometime between 1926 and 1937. Other enterprises that have occupied this space included a gas station and a small sandwich shop, the roofline of which can be seen on the gable end of the Lightner Store.

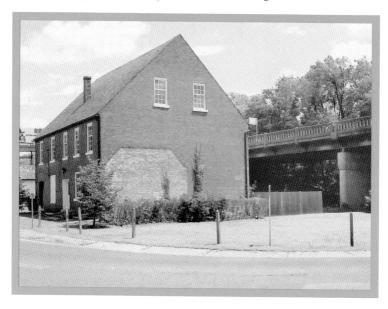

The original house at 100 King Street was built in 1909 by Nelson Payne for his new bride, Nannie Mills. Payne sold the house to Billy Sacrey in 1927. In 1997, significant changes were made to the dwelling. The clapboard siding was replaced with brick veneer, the earlier-20th-century additions were replaced by two-story additions, the front porch columns were replaced, and a railing was installed on the porch roof.

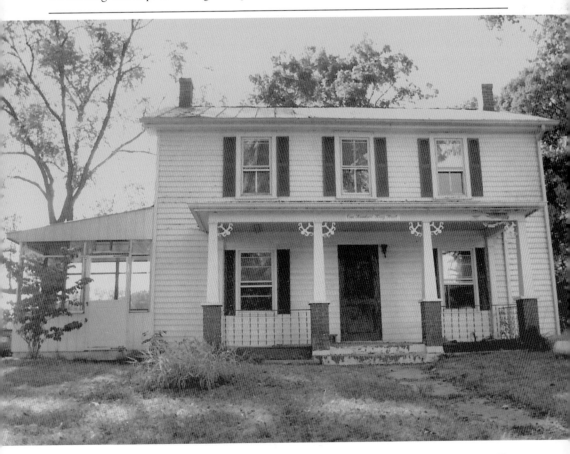

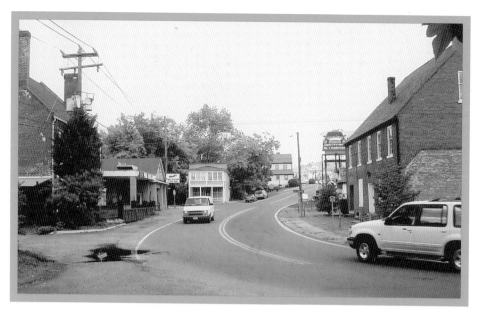

The *c.* 1901 image records the view looking north up West Cambridge Street from the bridge to Fredericksburg. It is possible to identify some of the buildings that still stand along today's streetscape. The buildings include the Cambridge Inn (originally an early warehouse) on the left with its double chimneys, the 19th-century Berry Store at center, and the Lightner Store (another early warehouse) on the right. After major flooding in the 1940s, the road connecting Falmouth to Fredericksburg was realigned, and the bridge over the Rappahannock was relocated to its current position.

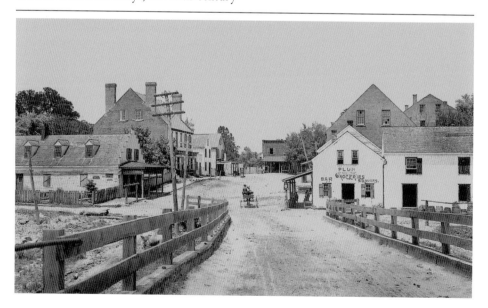

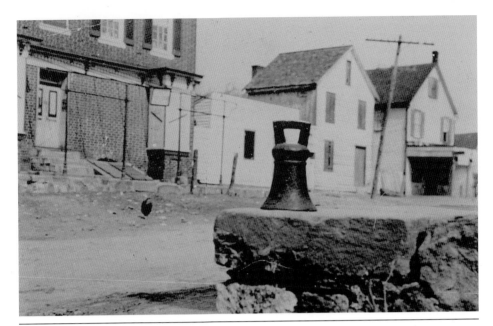

The photographer of this 1930s photograph was recording the bronze tobacco weight sitting on the stoop of the Lightner Store. The weight was used for weighing fractional quantities of tobacco before shipment to England and is marked "Falmouth Warehouses 1773." What may be even more interesting is the streetscape in the background showing the Cambridge Inn at the left of the photograph and a number of frame buildings; the flat-roofed building sold meat. An auto repair garage has replaced these structures.

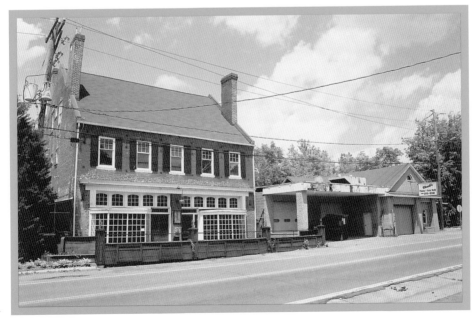

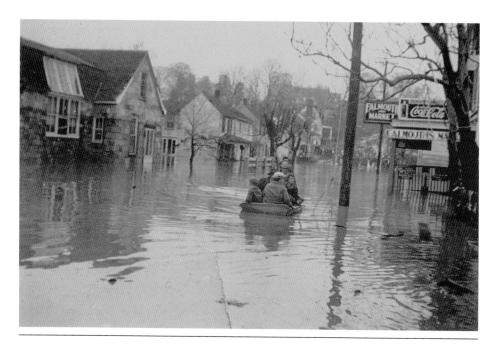

Looking west up Washington Street toward Belmont, this 1942 flood image shows the extent of the flood waters. Area residents float by A. Cox's Falmouth Market on the right and the stone building once used by the Melchers as a studio on the left. Most recently, the Falmouth Market has been used as a meeting place for the Beam of Light Pentecostal Church and is currently an office. The Barnes House can be seen right of center in the photograph. (T&AJ.)

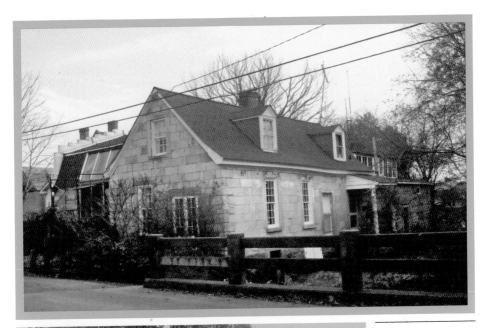

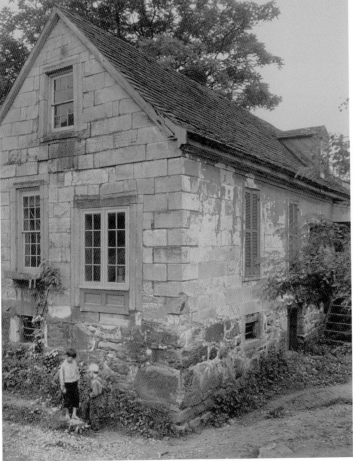

This distinct Aquia stone structure located on the south side of Washington Street was once used by Gari Melcher, a prominent early-20th-century artist, as his first art studio in Falmouth. A local reference refers to it as Corinne Melcher's studio. Before its use by the Melchers, it is believed to have been a bakery. At one time, theatrical presentations were performed for the public in the building. (LOC, FBJ.)

The Temperance Tavern was built as a warehouse by William Brooke Jr. around 1820. The gable end faces Washington Street; the long axis is the front. About 1835, Washington Street became an avenue west, and Brooke added chimneys and changed it into a tavern and dwelling. In 1840, Conway and Slaughter bought the tavern. Insurance policies of this period refer to the building as Temperance Hotel. In 1886, John Brown bought the tavern and used it as a dwelling, as have its subsequent owners. (LOC, FBJ.)

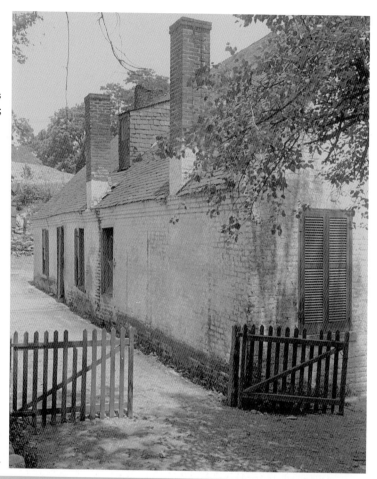

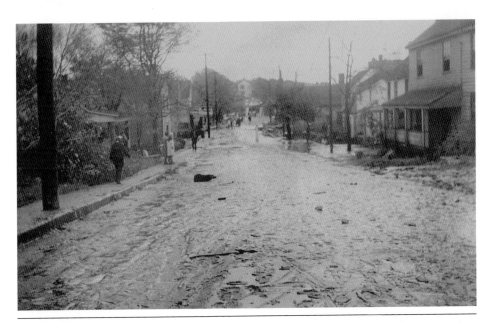

This view of Washington Street, looking toward U.S. Route 1, shows the mud deposited in the street following the 1942 flood. Temperance Tavern and the Barnes House stand just out of view on the left and right respectively. The home of Ted and Anne Jones can been seen at the end of the street on top of the terrace where today's U.S. Route 1 leads to the Falmouth Bridge.

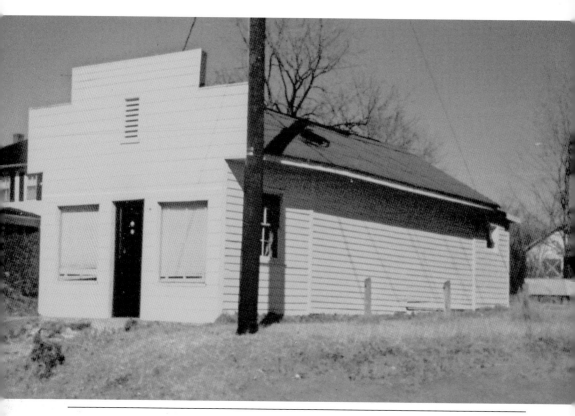

Originally located at 589 Melcher Drive, this store was run by the Wyne family, who built and lived in the dwelling located at the same address. The location of the store, next to the then–Gayle Middle School, made it convenient for the Wynes to sell candy and pencils to the students. The store is no longer standing, but Alec Hughart points to the store's stone stoop that marks the spot of its location. (BF.)

CHAPTER 3

HARTWOOD DISTRICT

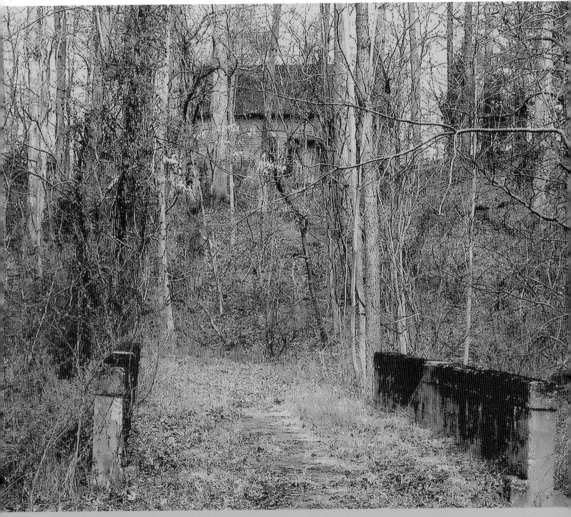

Now by-passed, this 1910 bridge spans Potomac Run where it crosses under Poplar Road. The concrete through-girder bridge was pre-cast in two sections and is one of the few remaining examples of this bridge building technique.

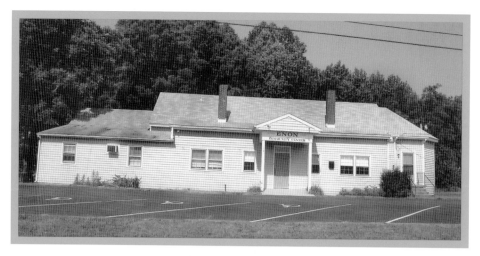

Enon School, built around 1930, is located at the intersection of Truslow and Enon Roads. A popular school plan in Stafford at the time, it still retains its polygonal apse, which accommodated the stage for school productions. An excellent example of adaptive reuse, the school is now the Enon Community Center. (BF.)

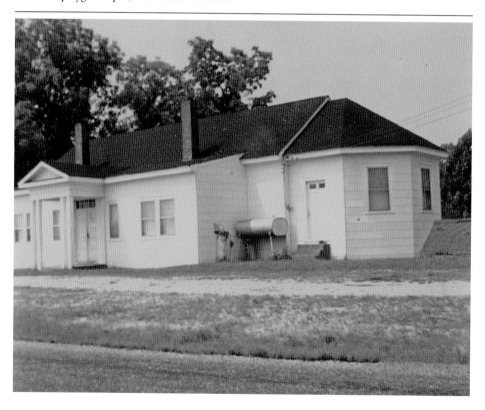

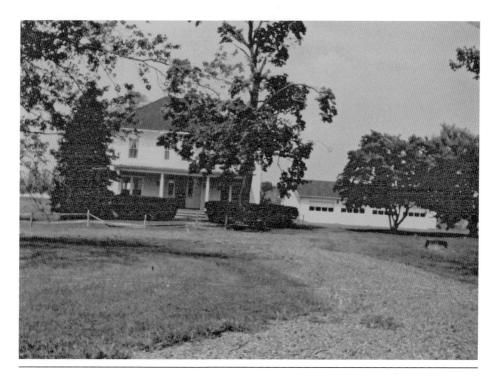

Spring Knoll Farm, also known as the Peden Place, was located on U.S. Route 17 in the Berea area of Stafford County. John and Louisa Curtis Peden constructed the house sometime in the late 19th century. John Peden was a justice of the peace and one of the first bridge commissioners in the county. When development threatened the house in 1994, it was moved to Fauquier County. The Stafford Tire and Auto building now occupies the house site. (BF.)

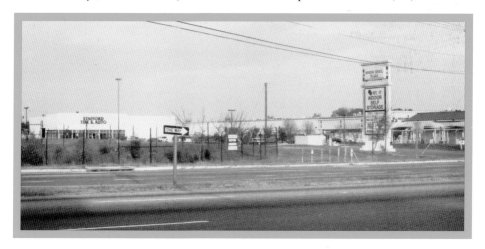

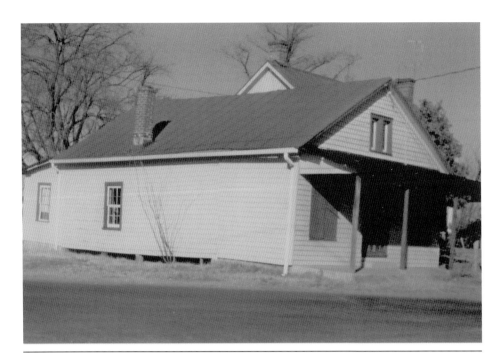

The no longer extant Wilber Heflin Store and Post Office was located on the corner of Berea Church and Fleet Roads. As with most of Stafford's country stores, the stores stood on the property of the person who owned the businesses and was often adjacent to the owner's homes. The roof peak and chimney of the Heflin House can be seen to the west behind the store.

Berea School, built around 1930, is located on the northeast corner of Berea Church and Fleet Roads. The school included grades one through five. The Berea School building has been purchased by the Berea Baptist Church for use as an annex. The church was established in 1852, when its early members broke away from the Union Church in Falmouth. (SH.)

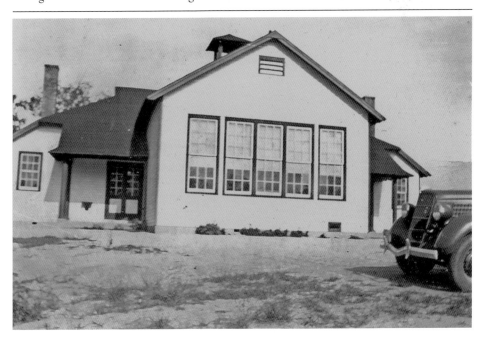

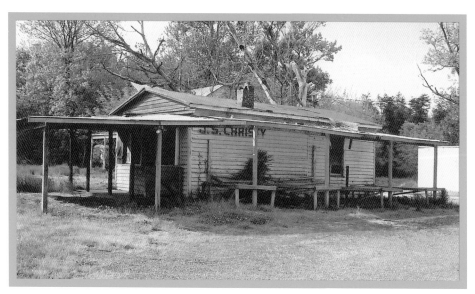

This *c.* 1900 store has been in the Christy family for two generations. Located at 1270 Warrenton Road, Joseph S. Christy first ran the store from a room at the back of the family home. The store operation expanded to include several store and nursery buildings. In the 1950s, the store and house were moved back from Warrenton Road to accommodate the widening of that road. Joseph's son, Milton, eventually took over the operation of the store. The property is currently scheduled for development. (BF.)

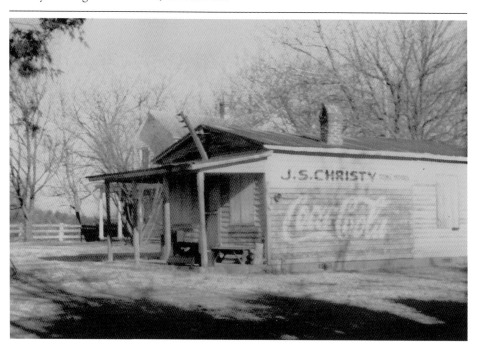

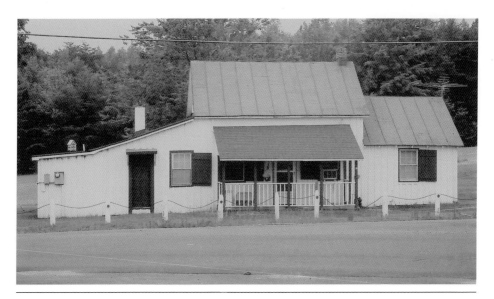

The Hemp Store and Post Office, located at the intersection of Hartwood and Hartwood Church Roads, was built around 1890 by Frank B. Stewart, who served as its postmaster until his death in 1931. Country stores often provided the service of a post office. The grocery operation was managed by James R. Monroe. Across the road, the Hartwood Post Office replaced the Hemp Post Office in 1964. Currently, the Hemp Store and Post Office is being used as residence. (HSJ.)

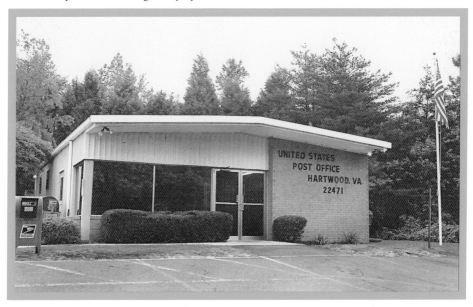

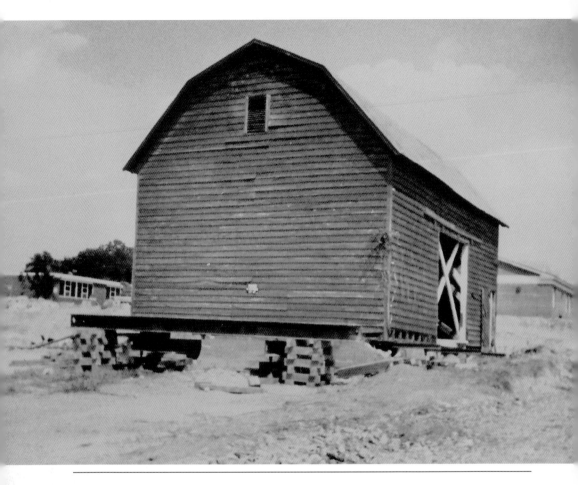

This barn, part of J. Stewart Jr.'s farm on the east side of Hartwood Road near its intersection with Hartwood Church Road, was built in the 1920s. Eventually the farm was sold to the Stafford County School Board for the construction of Hartwood Elementary. In 1993, to accommodate additional playing fields at the school, the barn was moved across the street. The Hartwood Barn is open to visitors on special occasions.

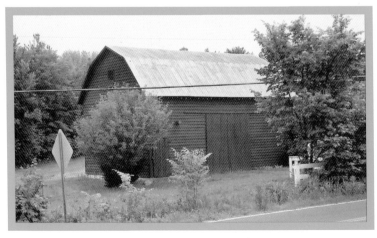

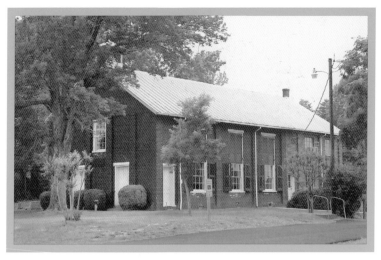

This church was constructed in 1858, replacing the Yellow Chapel Church, where the Hartwood Presbyterian Church congregation had met since around 1825. During the Civil War, both the Union and Confederate forces used the building, and a small cavalry engagement took place nearby. After the war, the interior of the church had to be completely restored. Civil War soldiers had removed all the wooden elements, including furniture, from the church to use for firewood. (HSJ.)

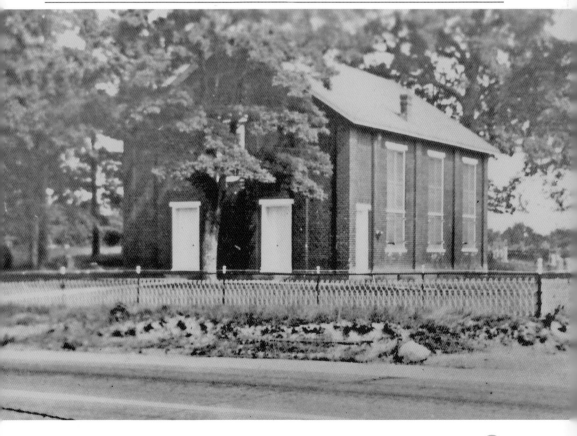

The C. B. Dickinson family, including children Elinor, Carl Jr., and Curtis, lived in this house. Like so many of Stafford County's late-19th-century farmhouses, the Dickinson family home is no longer standing. The family home was taken down in 1989. C. B. Dickinson's daughter, Elinor, constructed the brick rambler at 129 Harwood Road that stands next to the site of the family home. (BF.)

The original wooded portion of the Dodds' cider mill was constructed in 1935 on Hartwood Road, about a half-mile south of Spotted Tavern Road. Robert Lee Dodd and his sons Cory Nelson and Morris Dodd ran the mill. Apples were ground for local farmers and to make apple cider. The cinderblock addition was constructed around 1964. In 1979, the original wooden portion burned. Members of the Dodd family continued the cider operation in the cinderblock structure until about 2000. (BF.)

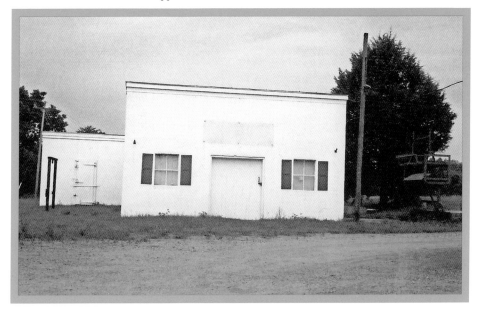

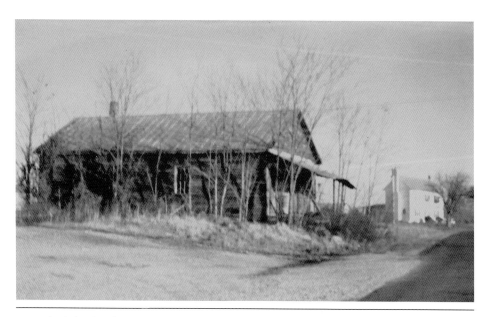

Typical of the family-owned and -operated country stores that dotted the Stafford County landscape in the early to mid-20th century, the Dodd Store provided the surrounding community with food, household goods, and a variety of notions. Run by Morris Dodd, the store was part of a complex that included the Dodds' cider mill. The store was located just north of the cider mill on Hartwood Road. The store disappeared from the landscape in 1977. (BF.)

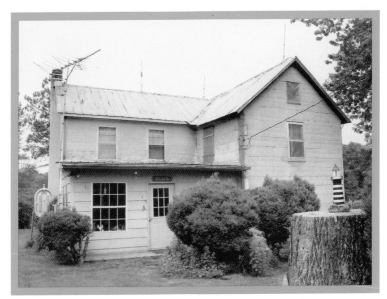

The Dodd family home was constructed by Alexander Bennett Dodd around 1882. The house, located at 1461 Hartwood Road, was the hub of a self-sufficient farm operation. Typical of most family farms in Stafford County, produce and animals were grown and raised for the consumption of the family. Any surplus was taken to the local country store and traded for items that were not produced on the farm. Family descendents still live in the house. (BF.)

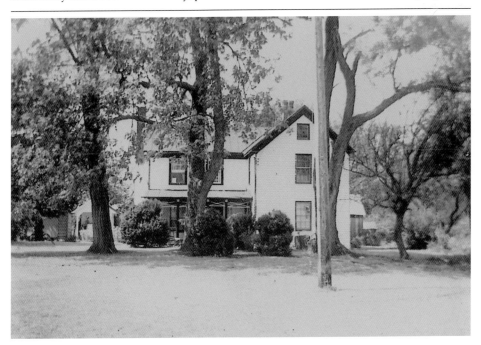

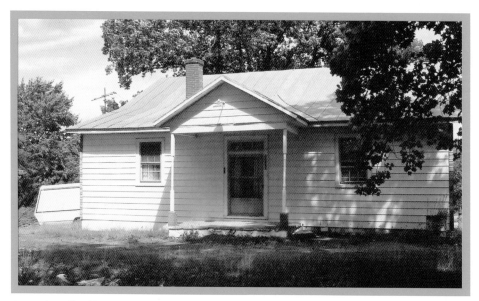

One of Stafford's two-room schoolhouses, Central School is located on Hartwood Road just north of Skyline Road. Built some time in the 1920s or 1930s, it replaced the earlier Central School located on Thad Green's property along Skyline Road. When a newer school was built, the building became a store that also provided a room for dancing. Recently it has been the home of Annie and Bollie Beach. (SH.)

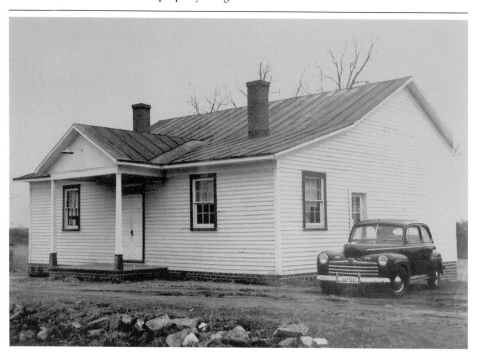

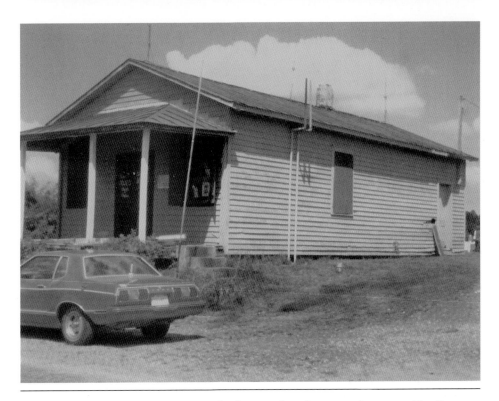

Thaddus and Corenne Beach Courtney both ran the Courtney Store. Located on Poplar Road near the Stafford/Fauquier County line, the store was constructed around 1910. The Courtneys established a family tradition of store owners, as family descendants operated a number of stores in the county. The Courtney Store retains its original interior and exterior architectural elements. In the last half of the 20th century, the structure was used to sell local crafts. Currently, it is being used to sell antiques and collectibles. (BF.)

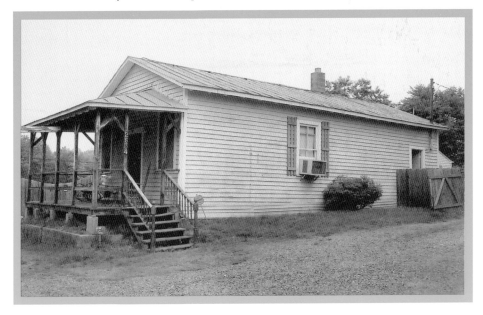

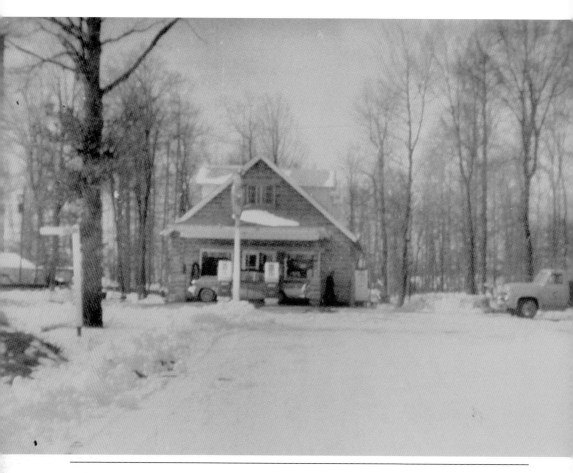

Concord Store, located at the intersection of Poplar and Mountain View Roads, was built by William and Anna Sterne in 1946. They lived with three of their seven children in the three-bedroom apartment above the store while their house was being built next door. Until it's closing in 2005, the store had been a link to the past and a fixture of the surrounding community. (BF.)

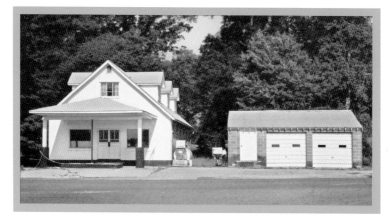

Poplar Grove, located on Poplar Road near the junction of Mountain View and Poplar Roads, has had three family homes constructed on the property. The first house was of stone and built by Quakers. For a brief period in the late 18th and early 19th centuries, Quakers moved into Stafford County from Pennsylvania. The photograph above shows the *c.* 1900 French/Fitzhugh house built on the foundations of the Quaker dwelling. The current house, a Sears mail-order structure, was built in 1934 after the *c.* 1900 house burned. (LVA.)

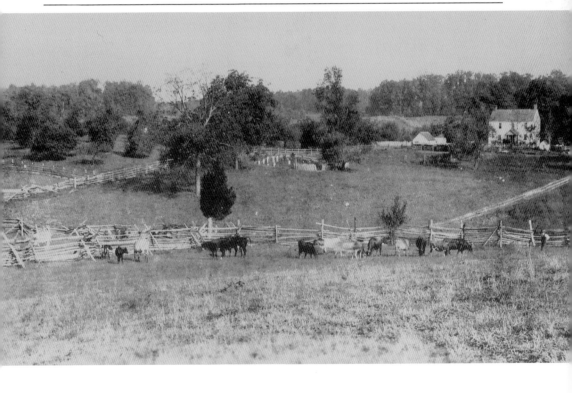

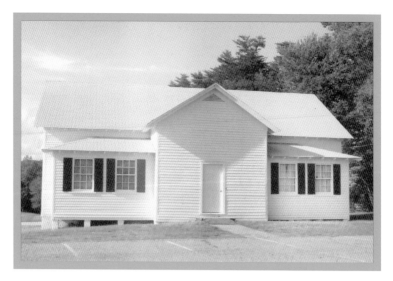

The Ramoth School, located at the corner of Ramoth Church and Kellogg Mill Roads, was built around 1930. The school accommodated grades one through six. Missing only its school bell tower, the building retains all of its other distinct architectural elements, such as exposed rafter tails and the central pavilion flanked by antechambers with half-hipped roofs. The structure is now being used by the Ramoth Baptist Church as an auxiliary building. (SH.)

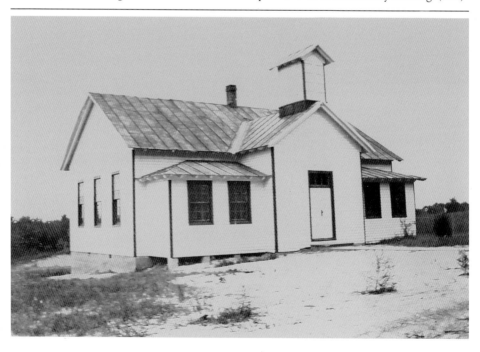

ROCK HILL DISTRICT

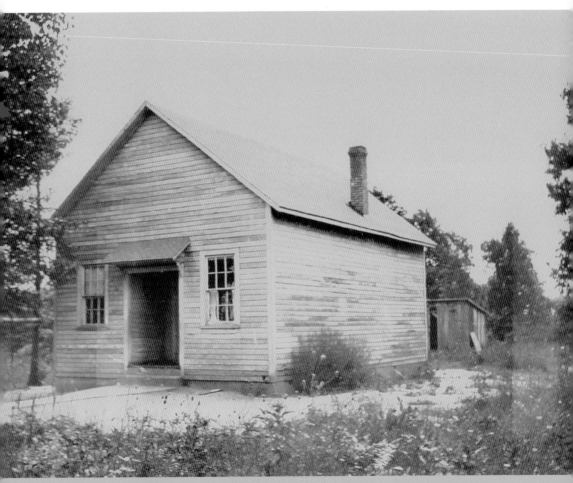

Located on Garrisonville Road near Skywood Drive, Shiloh/Ruby School was constructed around 1920. In the 1960s, the building was moved one half mile west of the small community of Ruby on Garrisonville Road. It was then rehabilitated as a dwelling by adding wings and brick facing. (SH.)

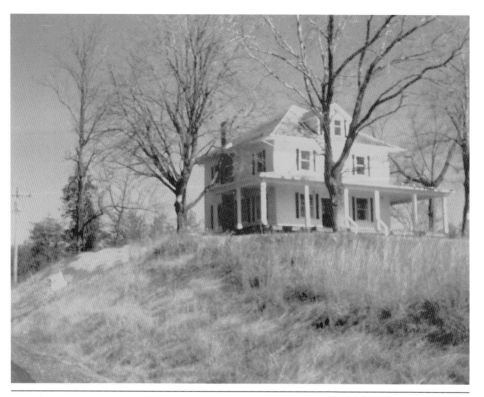

The Rose house, located at the intersection of Joshua and Mountain View Roads, was built around 1920 by James M. Rose. The Rose family ran a country store nearby on Mountain View Road from 1885 until 1949, when the Tolson family bought the store. James Rose was a postmaster and known as the unofficial "mayor of Roseville" while operating the store. (BF.)

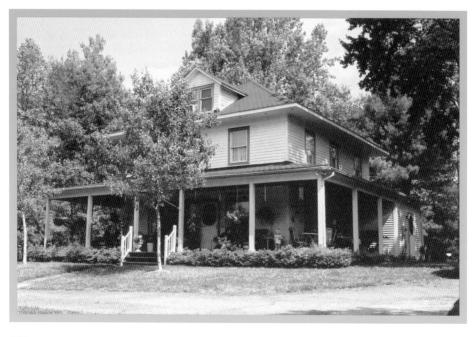

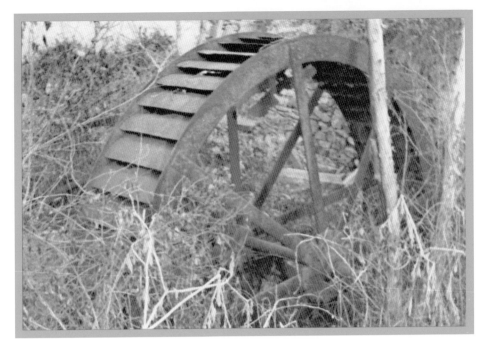

Established around 1809 by Charles Tackett, Tackett's mill and store was located on Tackett's Mill Road between Heflin Road and Barrington Woods Boulevard. Subsequent owners of the mill included Robinson and Lawrence Skinner. The Skinner family operated the mill into the 1940s. The waterwheel and other remains of the mill were removed in 1982 to a Prince William County shopping mall. A few years later, the miller's house was struck by lightning and burned. (BF.)

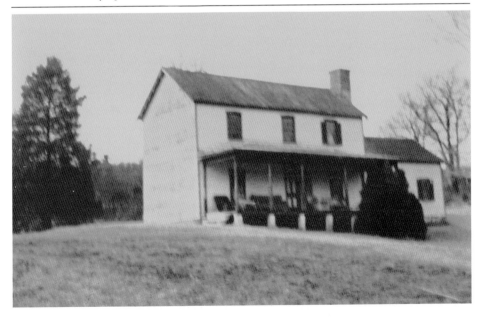

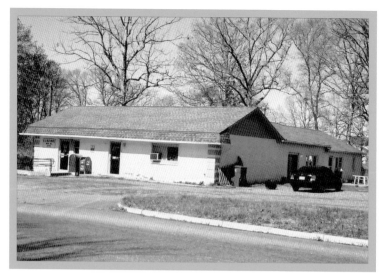

Ruby Post Office was established in 1903 by Mildred Rose. Later postmistresses were Fannie and Hazel Heflin. When Heflin resigned, Ruth Eustace was appointed postmistress. She purchased the building in 1948 and moved it to her property on Garrisonville Road east of Green Acre Drive, where it stands today. The Ruby Post Office operation has since been moved to a new building at the intersection of Garrisonville Road and Arrowhead Drive.

The Rockhill Baptist Church is located about a mile north of the Old Rockhill Methodist Church on Rockhill Church Road. In 1812, the Baptist members split from the Old Rockhill Meeting House and established their own church. The congregation first met in a private home while waiting for their church to be constructed. As the congregation grew, additions have been made to the building. (BF.)

Located at 459 Rockhill Church Road, Old Rockhill Methodist Church was first used as a meetinghouse in the early 1800s. The meetinghouse was known as a free church, which meant that all denominations worshiped together. Eventually, each denomination split off and established its own church. By 1860, the meetinghouse was being used solely by the Methodists. After the Civil War, the church was also used as a school. By the early 20th century, the church was converted into a dwelling. (BF.)

Garrisonville School's L-shaped plan and rear second story supported by pillars, which supports the cupola for the school bell, is in sharp contrast to the modern style of the current Garrisonville Elementary School. Today Garrisonville Elementary School, located within Garrisonville Estates on Wood Drive, is part of a large school complex that includes A. G. Wright Middle School and Rockhill Elementary School. (SH.)

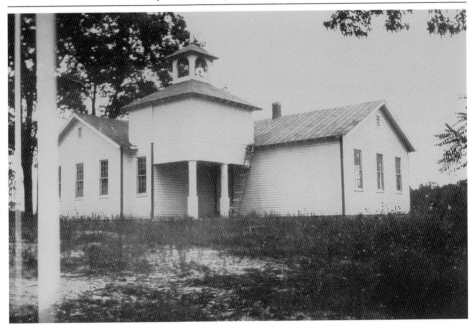

The Patton House was located at 1198 Garrisonville Road. The Patton family home was built around 1920. The exposed rafter tails and the full-width, one-story porch with Doric columns are the distinguishing features of this house. The house was demolished in 2005 to allow for the construction of the North Stafford Center for Business and Technology.

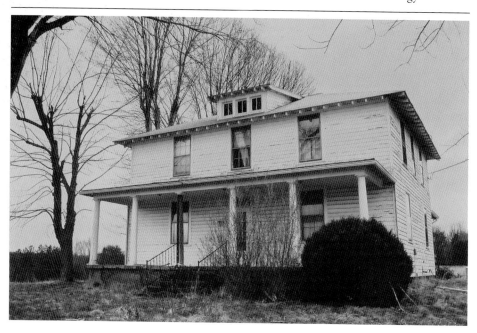

Aquia District

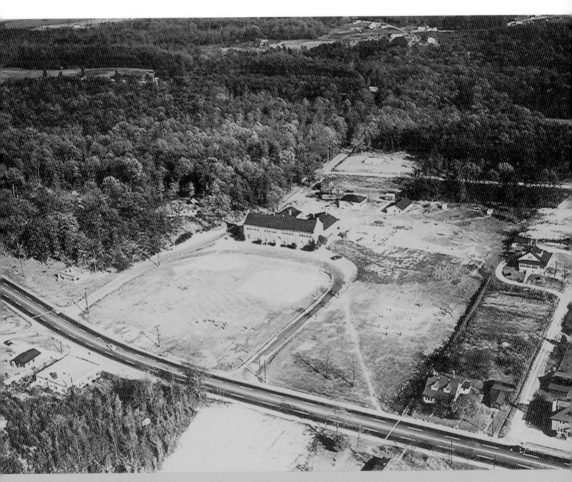

The current location for the Stafford County courthouse was chosen around 1783. A small community grew around the courthouse, jail, and clerk's office. By the time this aerial photograph was taken of Stafford High School around 1935, bungalow homes, a motel, and a store were visible along U.S. Route 1. Today the building is utilized by Stafford County public schools as administration offices, and the small houses and shops are making way for office buildings and housing developments.

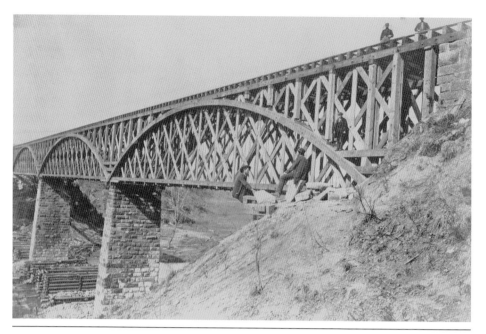

Initially destroyed by retreating Confederate forces, the Richmond, Fredericksburg, and Potomac (RF&P) bridge over Potomac Creek was rebuilt three times by Union forces. The bridge was a critical component of the rail system, which allowed supplies to advance with Union forces as they pushed into the South. The April 1863 photograph shows one of the reconstructed bridges. Today the stone abutments are all that remain and are interpreted as part of the Virginia Civil War Trails. (LOC.)

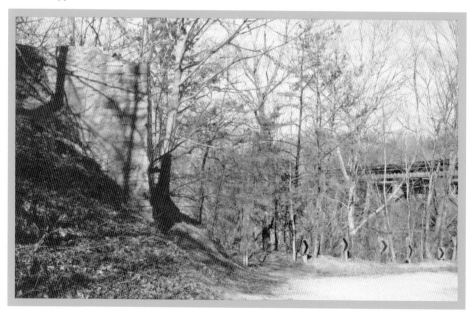

Motor courts and small, family-operated motels were once common along U.S. Route 1 as it runs north and south through Stafford County. Pictured is the Fredericksburg Motor Court, which was located seven miles north of Fredericksburg, Virginia, on U.S. Route 1. The motel was "Duncan Hines Recommended" and featured modern central heating, masonry construction, and soundproof walls for patrons' comfort. Early in 2005, the motel was demolished. It was also called the Sportsman Motor Court and Bradshaw Motel.

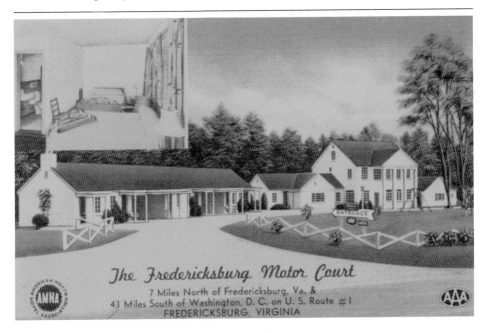

The Fredericksburg Motor Court
7 Miles North of Fredericksburg, Va. &
43 Miles South of Washington, D. C. on U. S. Route #1
FREDERICKSBURG, VIRGINIA

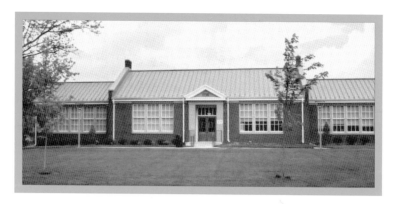

The *c.* 1955 photograph shows students at H. H. Poole Jr. High School. Dedicated in 1954, it was the first junior high school for African American students in the county and was the largest school for Stafford County's black students during segregation. After integration, the building was renamed Rowser Education Center. Around 2004, the building was remodeled and rehabilitated. It now serves as the administration offices for Stafford County Parks and Recreation located on U.S. Route 1. (SH.)

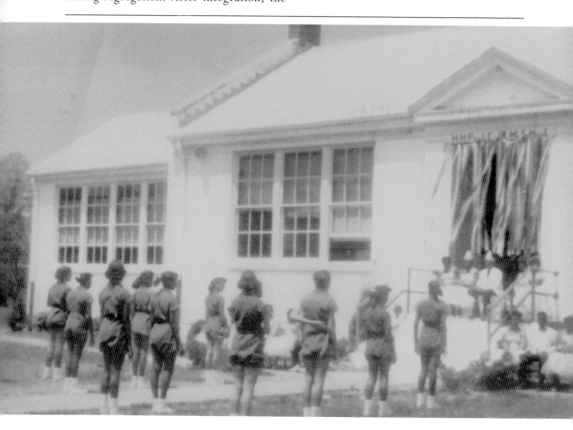

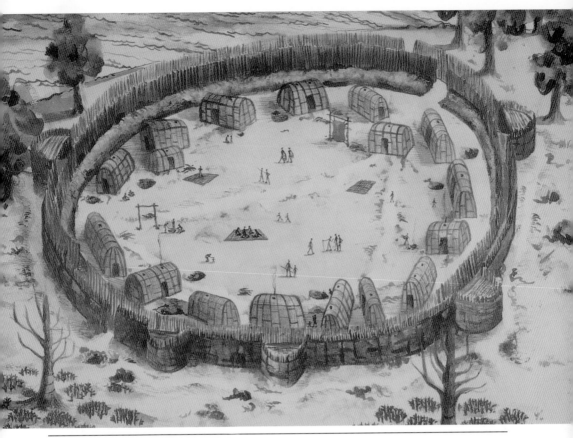

The Patawomeke site located on Indian Point dates to the Late Woodland Period, around 1500 AD. As illustrated in the sketch by Shelley Pomerleau on a VDHR poster, the Patawomeke village was surrounded by a palisade. The Patawomekes lived in the huts protected by the palisades and grew crops such as corn, beans, and squash in fields outside the palisade. Archaeological investigations of the village began in the 1930s and have been periodically conducted up until a few years ago.

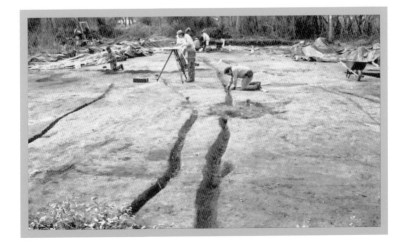

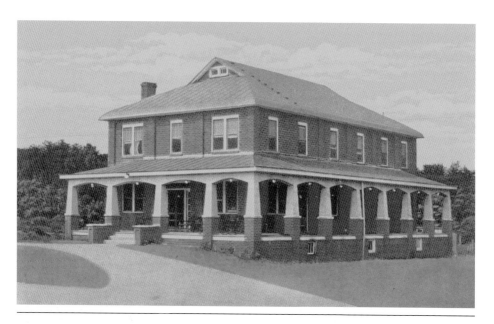

The Hotel Virginia was one of two hotels in the courthouse area. The hotel was described on the back of the postcard above as being located "on the Richmond–Washington Highway, forty-four miles south of Washington, ten miles north of Fredericksburg" and featured all modern conveniences and old Virginia cooking. Since around 1972, the building has been utilized as offices for Aquia Reality.

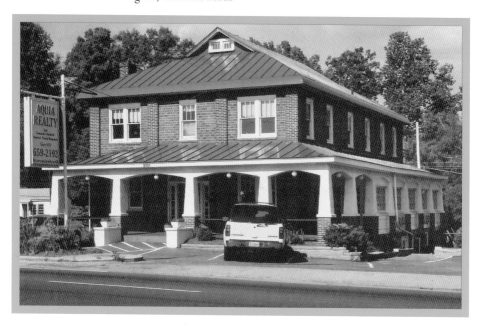

Harwood family house was located on the south side of Courthouse Road near the intersection of Courthouse Road and U.S. Route 1. Sitting on a hill, it had a commanding view of the surrounding area. The original L-shaped farmhouse built around 1879 had several additions made to it in the early 1900s. The distinctive architectural feature of the home was its wraparound porch. The dwelling was used for a firefighting training exercise and destroyed in 2002.

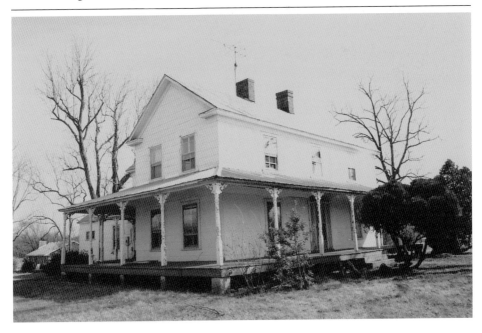

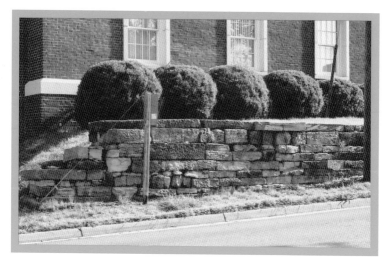

Part of the original courthouse complex, the county jail, constructed around 1783, was located to the east of the courthouse on the opposite side of Telegraph Road. The building was approximately 20 feet square, two stories high, and built of sandstone. The jail was torn down in the 1920s to facilitate the alignment of U.S. Route 1. Some of the sandstone blocks were salvaged and used in the construction of the retaining wall on the south side of the courthouse along Courthouse Road. (LOC.)

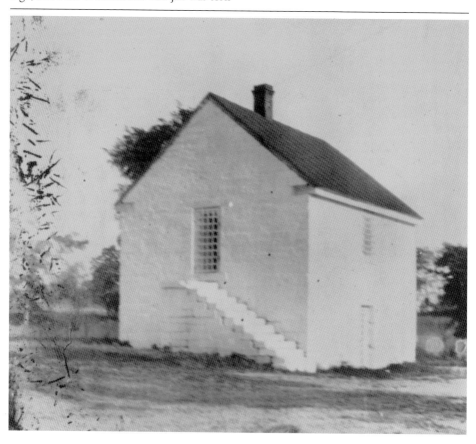

AQUIA DISTRICT

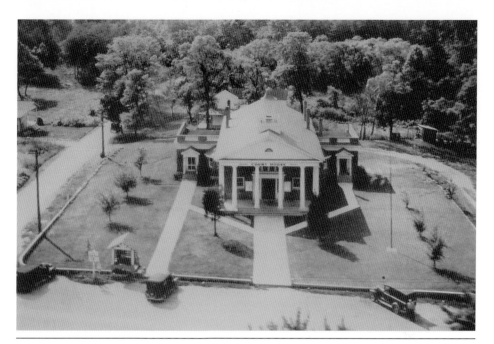

This c. 1930 aerial photograph shows the 1923 Classical Revival courthouse, lawn, well house, and U.S. Route 1. The building was constructed over the foundation of the c. 1783 courthouse and oriented to face the east and U.S. Route 1. Several additions have been made to the building, most notably the c. 1991 expansion along with the construction of the county administration building to the north and parking to the west.

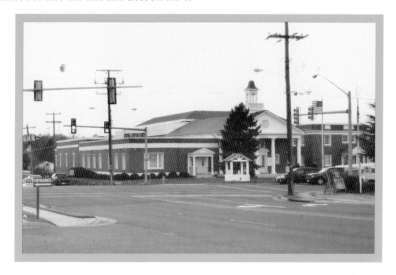

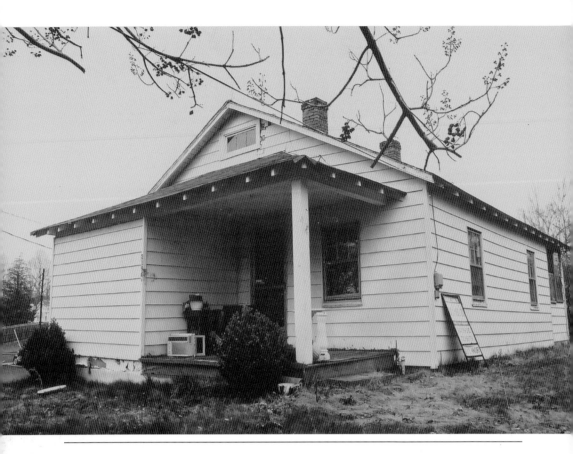

Located at the intersection of Hope Road and U.S. Route 1, the *c.* 1930 bungalow with exposed rafter tails was indicative of the small, single-family homes that were common in the courthouse area during the early to mid-20th century. The home was demolished in the summer of 2004. In 2005, a multi-use commercial building was constructed on the site. The building serves as general office, retail, and restaurant space.

The *c.* 1870 RF&P section house was a one-and-a-half-story frame building that faced the railroad tracks where they cross Aquia Creek. The house is similar to other railroad-related dwellings along the corridor. The building was scheduled for demolition around 2000 to allow for the expansion of Hope Springs Marina, located at the end of Hope Road.

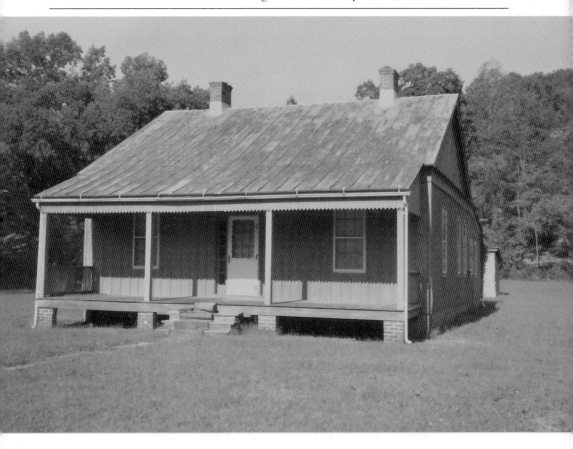

The Fleurry's was a late-18th-century home with a *c.* 1850 addition and was located in northern Stafford County near the present-day intersection of Garrisonville Road and U.S. Route 1. The house was home to the Green, Suttle, Fleurry, and Moncure families. It was demolished around 1987 to make way for the development of Aquia Town Center. The 18th-century portion and kitchen were relocated to Aquia Church and rehabilitated to serve as a vestry house. (MCK.)

This late-1940s photograph taken from the Fleurry's driveway shows Telegraph Road in the foreground and U.S. Route 1 in the distance. Telegraph Road was one of the primary transportation routes through the county before it was replaced by U.S. Route 1 in the 1920s. Today U.S. Route 1 is seven lanes wide at its intersection with Garrisonville Road. (MCK.)

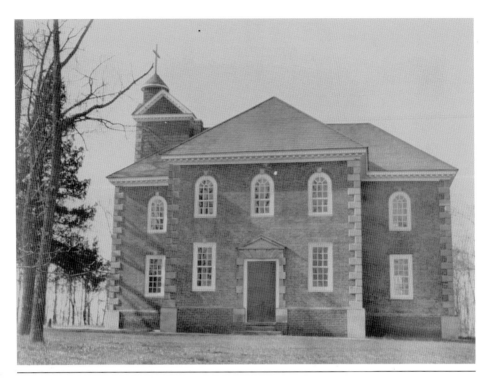

The 1751–1757 Aquia Church, located near the intersection of Routes 610 and U.S. Route 1, was built in the form of a Greek cross and features two tiers of windows, brick construction, and sandstone quoins. The earliest use of the graveyard occurred around 1838. It was not until the relocation of several family burial grounds in the early 1900s that the graveyard was commonly used by members of the congregation. (LOC.)

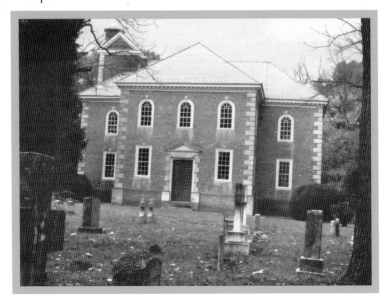

GARRISONVILLE AND GRIFFIS-WIDEWATER DISTRICTS

The ruts left in the sandstone bedrock of the Robertson-Towson quarry site on Austin Run are one archaeological resource that remains from the late 1700s Aquia stone quarries. The quarries, along with seine fisheries, were the dominant commercial activities of the districts well into the early 20th century. Today commercial activities include retail stores, restaurants, gas stations, and office parks.

87

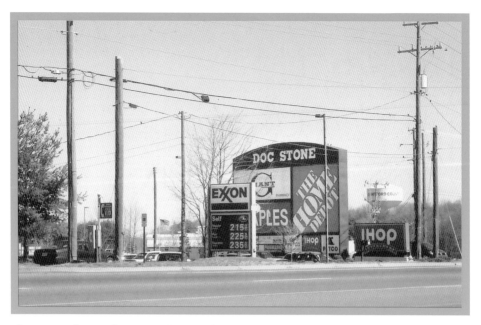

The *c.* 1898 house shown was home to the Stone family and was built on top of an earlier family home, which was associated with Dr. Hawkins Stone. Dr. Stone (1816–1903) served as the doctor for Stafford County residents for over 60 years. The house was demolished around 1999, when the site was developed as a shopping center. Doc Stone Commons is located on Garrisonville Road.

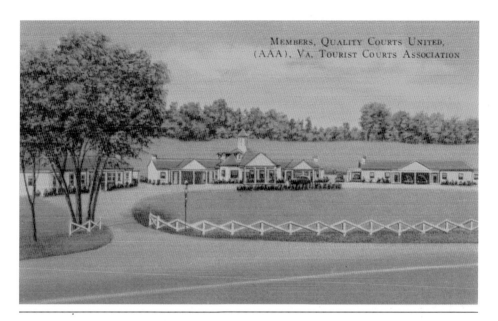

MEMBERS, QUALITY COURTS UNITED,
(AAA), VA. TOURIST COURTS ASSOCIATION

Spring Lake Motor Court was described as located 34 miles south of Washington, D.C., and 16 miles north of Fredericksburg on U.S. Highway 1 with a Rectory, Virginia, mailing address. Rectory was the name given to the general area and associated with a home and post office located off nearby Widewater Road. Though it has been altered, the motor court retains its original design and layout and is now called Spring Lake Motel.

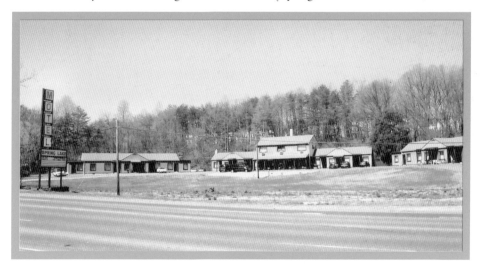

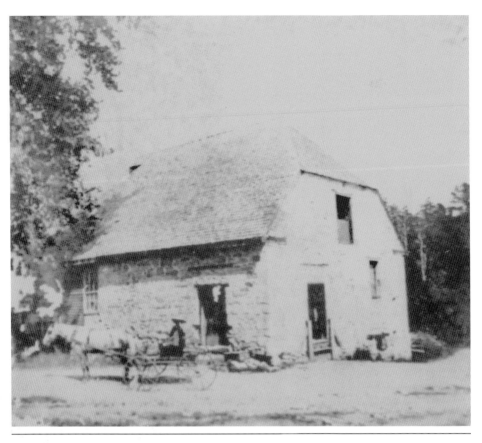

Brent's Mill stood near the intersection of Widewater and Decatur Roads. The *c.* 1650 mill, which ground corn, wheat, and rye, made use of the waterpower provided by the nearby run. The mill and associated store, distillery, and blacksmith shop were a center of the community for many years. Brent's Mill was damaged by fire in 1901 and was dismantled. The general area remains a community center and has been the location of both the Widewater grocery and fire station. (MCK.)

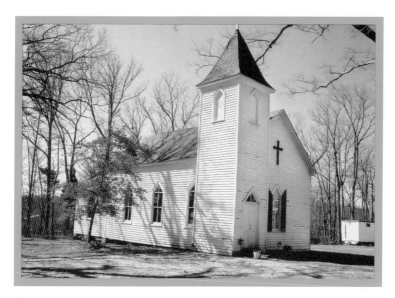

Clifton Chapel was built in the mid-1800s to serve as an Episcopal chapel of ease for the Widewater community and did so until the 1950s. Located off Clifton Chapel Lane, the site was known as Camp Clifton by the 47th Virginia Infantry, who used it as a defensive position during the early years of the Civil War. The chapel has been restored at least twice, once after the Civil War and most recently between 1999 and 2001. (MCK.)

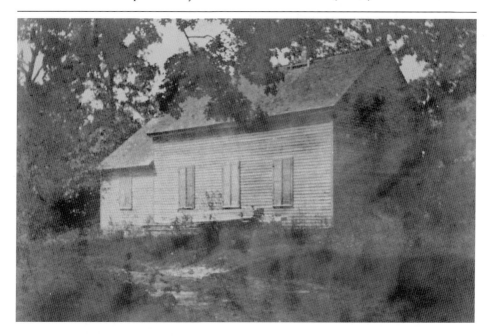

Clifton, located off a private drive on Widewater Road, was the home of the Clifton family in the 17th and 18th centuries and has remained in the Waller family since the mid-1800s. The Waller Fishing Shore was located here and was the largest seine-fishing industry in Stafford County. The fishing operation was carried out on the shore of the Potomac River below the house, which was lost to fire in 1945. Another home was built near the old foundations around 1970. (MCK.)

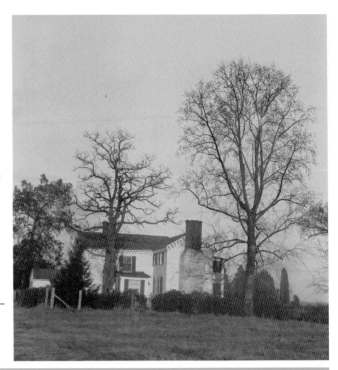

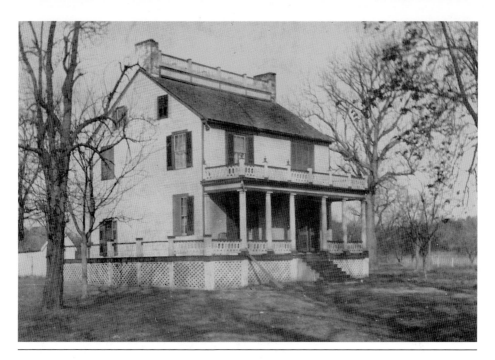

This *c.* 1787 private home is located on Widewater Road and is the second house to stand on this site. Richland was once the hub of a busy plantation operation that included approximately 1,000 acres and has been home to the Brent, Fitzhugh, Waller, Lee, Pyke, and Kendall families. Around 1900, the Pykes built a chapel in the house so that priests could come from Fredericksburg to hold mass, the first since the days of the Brent settlement around 1700. (MCK.)

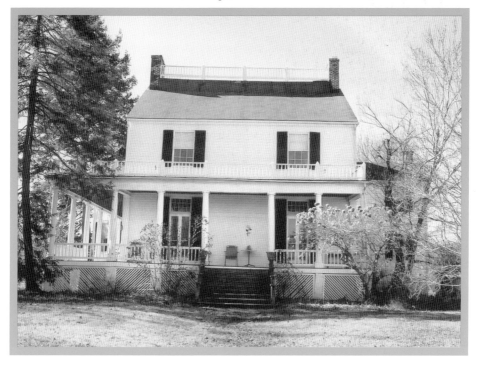

Outbuildings, such as dairies, barns, chicken coops, and smokehouses, were common features in the work yard associated with an early home site. While Richland's earlier outbuildings are gone, a rehabilitated smokehouse now stands northwest of this dwelling. The smokehouse was relocated to the site in 1987, when Fleurry's, a Moncure family home, was demolished. (MCK.)

The late-1940s cinderblock Widewater post office is located at the end of Widewater Road near the intersection with Arkendale Road. The post office replaced an earlier frame building, which was attached to a country store. A blacksmith shop as well as passenger and freight stations were located within the immediate vicinity. The post office was closed in 1959. (MCK.)

ACROSS AMERICA, PEOPLE ARE DISCOVERING SOMETHING WONDERFUL. *THEIR HERITAGE.*

Arcadia Publishing is the leading local history publisher in the United States. With more than 3,000 titles in print and hundreds of new titles released every year, Arcadia has extensive specialized experience chronicling the history of communities and celebrating America's hidden stories, bringing to life the people, places, and events from the past. To discover the history of other communities across the nation, please visit:

www.arcadiapublishing.com

Customized search tools allow you to find regional history books about the town where you grew up, the cities where your friends and family live, the town where your parents met, or even that retirement spot you've been dreaming about.